CENT PER CENT INDIAN

C. Ex. Reg. No.
MF 4101010010
GTC IND. LTD.
MUMBAI

ALL TAXES
INCLUSIVE OF
MRP Rs.17.00
20 CIGARETTES

CENT PER CENT INDIAN

C. Ex. Reg. No.
MF 4101010010
GTC IND. LTD.
MUMBAI

ALL TAXES
INCLUSIVE OF
MRP Rs.17.00
20 CIGARETTES

CENT PER CENT INDIAN

C. Ex. Reg. No.
MF 4101010010
GTC IND. LTD.
MUMBAI

ALL TAXES
INCLUSIVE OF
MRP Rs.17.00
20 CIGARETTES

CENT PER CENT INDIAN

C. Ex. Reg. No.
MF 4101010010
GTC IND. LTD.
MUMBAI

ALL TAXES
INCLUSIVE OF
MRP Rs.17.00
20 CIGARETTES

CENT PER CENT INDIAN

C. Ex. Reg. No.

100% INDIA

CATHERINE GEEL & CATHERINE LÉVY

100% INDIA

SEUIL · CHRONICLE

CONTENTS

INTRODUCTION

The pages that follow are filled with treasures gleaned from Mumbai's* bazaars, discoveries made on Indian shelves: You'll find electric lightbulbs in wild shapes, lopsided hand-blown glasses engraved with delicate flowers, tiny boxes injection molded from cheap pink plastic, shining stainless-steel kitchen utensils, a gearshift knob cast from transparent resin with a flower embedded in it, a black-flecked electric iron, and a radio-cassette player with twinkling arabesques—and don't forget the layer of dust that clings tenaciously to everything, driven away by feather dusters at market opening time in the morning and again an hour later.

These products are neither rare nor precious and until now have not attracted much interest. They are everyday objects Indians have been using for decades; of industrial or semi-industrial manufacture, they were not produced by artisans or craftsmen. They were collected between 1996 and 2003 and made, for the most part, after 1991. This date marks a decisive turning point in the economic and social history of India: At that time, the earlier era of rigorous protectionism began to relax, and the country's borders slowly began to open to the importation of products from abroad.

The objects depicted here, chosen at first for a simple appreciation of their form and function, were purchased in the bazaars and specialized boutiques of cities such as Delhi**, Mumbai**, Jaipur, Bangalore**, Ahmadabad**, Calcutta**, Indore, and Agra. Throughout the 1980s and 1990s, the middle class sought and used these products, but the prestige of such merchandise has gradually diminished, and the market has slowly shifted toward the less fortunate among the population, now made up of the inhabitants of the countryside and the underprivileged urban classes***. Taken as a whole, these items represent a distinctive time, a particular way of life.

A final cohesion we did not suspect emerged from these seemingly random objects. We began to realize they are slowly beginning to disappear. Every year, it is becoming more difficult to find parti-colored lightbulbs, and there are ever fewer flashing radio-cassette players, Royal Enfield motorcycles, or tin toys. If they sit on the back shelves today, displaced by consignments from Hong Kong, Taiwan, or mainland China, we may well think that in a few years, they will not be found at all. The reasons for this disappearance are related to India's economic aspirations and to the increasing globalization of trade.

The ragtag collection displayed in these pages may be thought of as a project of preservation. These objects have been photographed as though recorded almost automatically by a field anthropologist in order to archive them, depicted against backdrops—here, everyday Indian fabrics—that isolate them from their environment. The captions join two sorts of references: on one hand, an informative description of the given object, and, on the other hand, any information we have been able to gather about it and the conclusions we have drawn from it.

We want to avoid reducing India to the exotic and kitschy, as may happen anecdotally; but, even more, we have tried here to evoke, through these mundane objects, the gestures and rituals that, in every culture, help us define ourselves.

* By an act of the Indian parliament in 1997, Bombay's name was changed to Mumbai, although the earlier form is still commonly used.
** These cities are all important points of production for the country's manufacturing or processing industries.
*** They are thus affordable to 65 to 70 percent of the country's inhabitants. In India, this proportion means 650 to 700 million people. Other products, such as an electric hand-mixer, may be affordable to no more than 10 percent of the population—which is still some 100 million people. (These estimates were suggested by two anthropologists and an Indian designer.)

WHY THE ESSENCE OF MODERN INDIA IS INDUSTRIAL

The objects featured in this book are a part of modern India, a generation of products born after independence, some of whose roots reach back to time immemorial. And we often tend to see India in terms of those ancient times. The country is preoccupied with social structures that seem obsolete, even cruel, to Western eyes, with runaway urban modernity, with the technical prowess of software programmers, with outsourcing by major international companies—but we rarely talk about Indian industry. And, yet, the essence of modern India is, economically and politically, an amazing tale of industry!

THE PATH OF ECONOMIC PLANNING

Industrial India is first and foremost a unique fusion of the goals of economic planning and self-sufficiency with the political objective of achieving autonomy, of maintaining autonomy, of becoming a "power."

As early as 1947, India's first prime minister, Jawaharlal Nehru, began to try both to bring to fruition and to some degree transcend two visions: that of the entrepreneurs (the Indian ruling class), and another, which he shared with Mohandas Gandhi, the father of modern India, of family- and village-based self-sufficiency; he joined to these the concept of nationhood. For Gandhi, this concept of the nation was certainly less central. To him, what was important was the society that would grow out of the struggle for independence: dignity restored to the people of India, to every Indian citizen, after colonization and exploitation.

For Nehru, the concept included dignity not only for India's citizens but also for India itself. Paramount for him was the political stature of the country: a self-sufficient and genuinely independent nation, outside of the sphere of influence of foreigners. In international politics, this concept would lead, at the Bandung Conference in 1955, to the birth of a genuinely new perspective among nonaligned nations: peaceful coexistence, an attempt to create a third force or alliance standing between the two great powers that divided control of the Cold-War world between them.

The Rise of "Poor Power"

Nehru was not about to depend economically on either of the two great powers, the United States or the Union of Soviet Socialist Republics (USSR). It was the latter, however, whose progress toward industrialization he admired, which would inspire him to develop and advocate an India that would be autonomous economically and industrially.

It is important to remember how much India's development owes to Gandhi's tactics: boycotts and civil-disobedience campaigns. Every Indian citizen could recognize his or her role in the country's economy as producer or consumer. Between 1930 and independence in 1947, Gandhi sought to renew the ties between a relatively Westernized middle class, the great masses of rural India (80 percent of the population in the 1950s), and the emerging urban proletariat. In this way, Gandhi established that the national revolution and the social revolution are inseparable.

For Nehru (who, unlike Gandhi, was a member of the intellectual elite, of a leading family, a Brahmin), the path to modernity lay through technology, and visible and ostentatious power: steel and heavy industry. Although he was influenced by Marxist theory, he was also opposed to doctrines; a humanist educated at Cambridge, he was bound to Gandhi by the transcendence of their differences. Although he rejected fanatical nationalism, he was impressed by the Soviet example

of economic planning and its embodiment of the participation of a multiethnic population in pursuit of a common goal. He would be inspired by this model, but his ambition was to achieve success through democratic means, without either forced labor or the sacrifice of individual liberties.

For him, the example of an Indian success was vital in order to demonstrate the validity of the principles of an open and democratic society beyond the Western world: India's capacity for power. Added to this vision was no doubt the desire to supplant China in an economic and political competition that would henceforth be undisguised. In this way, according to some, India began to seek international recognition, rather than the advancement of its own citizens. By concentrating on heavy industry, India chose to become a "poor power."[1] According to Max-Jean Zins,[2] "In fact, India was at first able to do economically what it would later do politically. . . ."

The Rise of Protectionism

In its industry, India already had several advantages: In 1911, it was the first country in Asia to acquire equipment for the production of steel when several powerful ruling-class families, such as the Tatas[3] or the Birlas,[4] decided to beat the English colonialists at their own game by developing Indian industry. In 1880, between at most seventy to eighty families controlled as an oligarchy what had been an English monopoly until the 1850s. Denied access to heavy production by the British, this entrepreneurial elite developed a production of finished goods (even then), like fans and carriage curtains.

The country had been spared the ravages of the two World Wars. An industrial base and an infrastructure were already in place. The raw materials were there. The human resources were practically unlimited, and were organized administratively. After independence, these businessmen were at least as eager as Nehru to establish a deep-rooted industrial infrastructure, and they clamored for private development. The principles of the mixed economy were established, blending state financing and private investment. Events such as the famine of 1943 in Bengal had at all costs to be avoided in the future.

The first economic plan, launched in 1951, concentrated on agricultural self-sufficiency—doubtless a little too rapidly, given the shortages of 1955 and 1956, which affected 230 million people and the state of Bihar in particular. The second plan had for its objective increased productive capacity, in particular in metals, which has a direct relationship with the products featured in this book.

Indians are wonderful negotiators and fine commercial strategists, and they were often eminently successful in procuring financial aid, technology transfers, or licensing (stainless steel with the Kulhman firm, for example) from the United Kingdom, West Germany, and the USSR, but also from New Zealand, Canada, and Australia, thanks to membership in the Commonwealth. They began to create private technological research institutes. Three-quarters of the natural resources lie within the country, and rigidly protectionist laws were established: The high taxes on manufactured goods arriving from abroad were effective in preventing imports. The foundation of foreign companies would also be discouraged. If they happened at all, they were sometimes short lived: India became notorious for forbidding the importation of Coca-Cola in 1971. Thus Thums-Up was born.[5]

PLANNING AND MANTRAS

In 1961, Nehru's slogan was "Power for every village in India,"[6] and, starting in 1974, nuclear reactors supplemented the country's hydroelectric plants. Steel-production facilities multiplied throughout much of the nation. In medium-size towns and around large cities, industries for transformation of raw materials into products also arose. Nehru's slogan also reflects the way in which subcontractors' workshops were established in numerous towns and villages.

Some economists see the politics of Indian economic planning and its administrative organization as "a mantra on national scale" in a system of "Brahminist socialism[7]." This structure was particularly advantageous to the upper castes of Indian society. Whether in the case of governments or political parties, positions of power were held by an elite more interested in abstractions than in realistic verification. In fact, the system established by Nehru reinforced a propensity toward abstraction and quantification far removed from practice on the ground. In addition, some saw Nehru's choice as an abandonment of those humanistic principles that led to the birth of India. Economist Amartya Sen observed that because the nation never emphasized human resources, public health, or education, the politics of economic planning in the end did little to further the individual development of the population.[8]

Licenses and Monopolies, Subcontractors and Distributors

Because the Indian government couldn't administer or control everything through planning, a system of licenses was adopted. Any manufacturing or production facility was henceforth subject to obtaining an authorization from the administration—and, very soon, they began to obtain them by means of bribes—which was supposed to foster a balanced distribution of manufacturing throughout the country. In fact, through this system, conglomerates arose that purchased and amassed licenses and gradually built monopolies. Some were watch-making concerns (Hindustan Machine Tools, in Bangalore), and others produced motor scooters or refrigerators. These conglomerates explain the rise of the great consortia, such as Kislokar (manufacturers of motors and pumps) or Birla (various consumer goods, from gadgets to cosmetics).

Until 1996, just under a thousand products—the list was compiled by the central government—were made in exclusivity by various businesses (with assets of 8 million rupees, or about $200,000)[9]. This was the situation with shoes, for example, which were declared a national monopoly in 1952. Today, 526,000 small factories, workshops, and studios represent 40 percent of private industrial production. Sixty million people work at home.[10]

The loser in this case was craft work, which received no aid and suffered from monopoly politics. By the end of the 1990s, however, laws aimed at discouraging monopolies were passed to prevent economic stagnation. The little bazaar workshops and craftspeople working in the streets are not always quite what they seem: More often than not, they're subcontractors for much larger companies that gather together products finished in this way; networks of wholesalers, then of peddlers, distribute their stock. For these reasons, products found in India between roughly 1960 and 1990 were, with a few very rare exceptions, manufactured solely and entirely in India.

The 1980s would see the rise of the petrochemical industry, particularly the Ambani group, and the organization of small workshops throughout the country; subcontractors were furnished with molds and the raw materials for producing plastic objects (buckets, basins, pitchers, and so on). These installations often took no precautions to safeguard either their workers or the environment, and the chemical wastes they produced are still extremely toxic. Sociologist Djallal Gérard Heuzé says of their workers that most could stand at most ten years in these workshops. The refinery in Jamnagar, opened in 2001, is the largest petrochemical refinery in Asia.[11]

Assisted by protectionism, these policies contributed to the creation of the Indian economy. This choice would have a detriment—the quality of goods produced: Though Goodrej refrigerators or Penjaj scooters are famous for their durability, the Birla trademark is a synonym for junk. Once a monopoly is established, businesses no longer have any incentive to maintain the quality of their products. By protecting and encouraging development of industries while protecting them from quality standards and international competition, the Indian government cut itself off from the worldwide improvement in standards.

THE DEBATE OVER PRODUCTS

Where Do You Stand?

Ever since the 1960s, a debate that is still active and always intense rages over the quality of Indian objects. By their thundering proclamations, the representatives of national pride on one side and their critics—those who do not find the products useful enough or well finished enough—on the other side, confront each other in interminable arguments and dueling articles in the press. Politicians, economists, businessmen, all join in the controversy. The ideology underlying their positions is obviously informed by their more or less sectarian political ideas about national identity, but it illustrates acutely the urgency Indian citizens feel in taking their place with regard to the rest of the world.

In fact, for some, the doubtful quality of manufactured goods is a reflection of cavalier Indian attitudes, and the necessary result of self-reliance, and stands in the way of mass exportation, as in the case of products from Asia (China, Taiwan, and South Korea). In any event, it is certain that the economic moderation in place for the last ten years abandons a certain number of products that are in competition with those from Southeast Asia. The latter are sold at prices that are sometimes lower, as is the case with household electrical goods, for example, and may be of much higher quality (consumer electronics and electricity, in particular). India, strong in its technological expertise and on the rise with regard to the rest of the world, will thus have to reposition itself in the market if it wants to produce manufactured goods.

According to Heuzé, centers of production and processing of heavy industry are evolving, move constantly, and threaten an already exploited population. New castes are being created, defining a changing social landscape seized by regular paroxysms of violence, as with the Mumbai riots of the 1990s. In a practical sense, bazaars, shops, and department stores in the metropolises adjoin and sometimes intermingle with slums and shantytowns. Unlike in the case of the *chawls* (tenements) of the nineteenth or early twentieth centuries in Mumbai, which were often organized around the way of life of each region or village, the physical proximity between the bazaars and the poorest Indians is often both brutal and joyous.[12]

Liberalization versus Free Enterprise?

Today, life expectancy for the average Indian has more than doubled, rising from thirty-two to sixty-eight years since independence.[13] In terms of agriculture, India has been self-sufficient since the middle of the 1980s. From the 1990s until the present day, annual economic growth, following the economic liberalization of the 1980s and the deindustrialization of heavy industry, has varied between 6 and 7 percent. In fact, under pressure from the business community, and in the midst of a difficult political situation (a state of emergency over the conflict with Pakistan), Indira Gandhi intensified what she called "liberalization." Frontiers and trade barriers came down, and economic partnerships were strengthened. India emphasized its relationships with Southeast Asia: A joint development zone was established, and several treaties were signed. India's economic relationships with China, its traditional rival, are today more substantial than those with Germany, for example.

From that time on, India began to produce an enormous variety of consumer goods and industrial products, and every year the nation imports more of them. All the same, free trade is not talked about. The subject is still sensitive, thanks to memories of the British occupation, and "free trade" has an unfortunate reputation, or seems to have too many bad connotations.

Nonetheless, according to the country's 2001 census, more than 25 percent of Indians (who number 1.071 billion) live below the poverty line, and 70 percent are dependent on agriculture.[14]

The Realities of Consumer-Good Production

The problem India must face stems from the fact, among others, that its small workshops and factories only rarely plan for fixed capital expenses and do not invest in modernization.[15] In the following pages, we will see plastic razors identical to metal ones made twenty years previously: The same molds are actually still being used. The system relies on the abundant and low-paid workforce to stay competitive.

One of the greatest challenges facing small business in India is how to extricate itself from this situation. The nation's annual growth has been 7 percent since 1991, better than China's. The production of consumer goods and products for the large internal market must, however, stay competitive. Twenty-first-century India is at a crossroads. Will the country gamble on exportation? Trade minister Murasoli Maran announced a five-year policy of incentives in 2002 (the tenth plan, 2002–2007) with the goal of increasing India's share of world exports from the present 0.6 percent to 1 percent,[16] and he identified two hundred products and twenty-five markets that need special efforts.[17] India continues to prove its ability to produce computers and communication equipment. The talents of Mumbai's film industry go without saying. Through it, India demonstrates its amazing talents for communication and seduction.

Now, we can unveil these everyday objects, the fragile and shimmering reflections of a country in the throes of change. It is unlikely Indians will choose to export many of them; at most, they will arrive on our shores to stock the shelves of some appreciative and daring importer.

1. We owe this term to Georges Sokoloff, used for an economic study of the USSR and the title of a book, *La Puissance pauvre* (Poor power), Fayard, 1993. Guy Sorman used this conception of India in his work *The Genius of India,* New Delhi: Macmillan, 2001.

2. Max-Jean Zins, professor of political science at the Centre d'Études et de Recherches Internationales (Center for International Research and Study), interviewed on March 18, 2004.

3. What has today become a major industrial group was founded by Jamsetji Tata (1839–1904), a Parsee from Mumbai, who first took over India's cotton industry, then created the country's first steel mills in 1911; J. R. D. Tata (1904–1993), whose mother was French, created what would become Air India. Since 1989, the conglomerate has been headed by his nephew Ratan (b. 1937). This group includes Tata Iron and Steel Co. (TISCO, steel), Tata Engineering and Locomotive Co. (TELCO, automobile manufacturing), Associated Cement (ACC, construction materials), Tata Power (energy), Tata Chemicals (chemicals), Rallis (pharmaceuticals), Tata Tea (tea), Tata Oil (gasoline), Tata Hydro (hydroelectric power), Tata Unisys (data processing), Voltas (engineering services), and many affiliates.

4. This Hindu family from the state of Rajasthan, nineteenth-century financiers and businessmen, entered the textile industry (cotton and jute) after 1914, then, by 1947, began to produce aluminum. Today, the group controls more than 200 firms, among them Gwalior Rayon Silk (synthetic textiles) and Hindustan Motors (automobiles).

5. "Drinks began to flow freely again in his honor: Scotch and soda, rum and Coke, brandy. Sarosh noticed that during his absence all the brand names had changed—the labels were different and unfamiliar. Even for the mixes. Instead of Coke there was Thums-Up, and he remembered reading in the papers about Coca-Cola being kicked out by the Indian Government for refusing to reveal their secret formula." Rohinton Mistry, *Swimming Lessons and Other Stories from Firozsha Baag,* Boston: Houghton Mifflin, 1989.

6. He was talking about electric power.

7. Jean-Alphonse Bernard, *L'Inde: le pouvoir et la puissance* (India: power and might), Fayard, 1985.

8. Indian economist, Nobel Prize in economy, 1998. Work cited: *India: Economic Development and Social Opportunity,* Oxford University Press, 1995.

9. Interview with Djallal Gérard Heuzé, researcher at the Centre National de la Recherche Scientifique (National Scientific Research Center), June 26, 2003.

10. Source: French Committee for Foreign Trade.

11. Interview with Djallal Gérard Heuzé, June 26, 2003.

12. *Mumbai-Mumbai: de fureur et de tendresse* (Mumbai-Mumbai: rage and affection), edited by Raïssa Brégeat-Padamsee and Djallal Gérard Heuzé, Éditions Autrement, 1999–2000.

13. Source: CIA World Fact Book.

14. Ibid.

15. Max-Jean Zins, research director at the Centre d'Études et de Recherches Internationales (Center for International Research and Study), interviewed on March 18, 2004.

16. Source: French Committee for Foreign Trade. This effort would require an average annual growth in exportations of 11.9 percent until 2007.

17. Ibid.

WHAT MAKES IT INDIAN?

Throughout the last half-century, from 1947 until today, almost every object of daily Indian life, from automobiles to lemon presses, has been made on the spot with greater or lesser ability, inspiration, skill, and difficulty. Gandhi and Nehru were convinced that they had to utilize and develop local resources, even local craftsmen, as much as possible in order to make India totally autonomous. To encourage Indians to support this goal, Nehru established strict import quotas and made it almost impossible to find foreign merchandise in the country. These early restrictions led to treasures stamped "Indian Quality" or "National"—dangerously shoddy products festooned with labels marked "OK Tested," which often invoke Lakshmi, Usha, Ganesh, and other deities.

Brightly colored or plain, practical or unnecessary, ornamented or unadorned, most of these objects are remarkably engaging. In order to stand out in the local market, and to compensate for the relative insufficiency of their production facilities, Indian manufacturers seek to outdo each other in creativity and ingenuity, heaping up a thousand ideas and flaunting design as their watchword. Their products' defects are more or less naively camouflaged, and their virtues are emphasized unabashedly. Boldly, they flaunt a staggering variety of forms and colors to make up for their sometimes dubious quality and unabashedly crude finishing touches; the colors often run together, electrical wires are frayed or hang loose, bulbs explode, knobs come off, paint bubbles and flakes. Impeccably finished items, if indeed they existed, were labeled "export quality" and sent off to conquer foreign markets. Those products intended to attract Indians alone stayed in India.

To cope with the demand, the local market provided a large quantity of bewildering propositions, faithfully reflecting the diversity of its clientele: As in "Goldilocks and the Three Bears," anyone could find a chair, a bed, or a bowl that was just the right size. There were almost always many sizes, qualities, colors, materials, and prices to choose from. A single product existed in as many incarnations as the country has religious communities, levels of wealth or poverty, and nuances of culture. A seductive shape compensated, at least to some extent, for an absence of solidity or safety. A final adjustment, by hand, almost always completed the manufacturing process, giving it an added attraction that seduced the customer by revealing its own identity.

This wide spectrum of options was possible thanks to the multiplicity of means of production, permitting the simultaneous existence of quasi-handmade objects produced in limited quantities and industrial articles manufactured in very great numbers. On the other hand, in "developed" Western countries, there exists almost no level intermediate between mass production and creation of luxury goods. The disappearance of small factories in the West, absorbed or driven out of business by bigger operations, has to a remarkable extent made the landscape uniform. The requirement for uniform quality—the cause of this phenomenon—has been changed into a pitiless instrument of standardization, and this uniformity has not only caused the disappearance of defective products from the shelves but has also wiped out individuality.

In India, still a long way from finding itself in such a situation, each purchase is like a kind of adoption. Every customer takes the time to have a shopkeeper unwrap ten copies of any item so as to be able to choose the best, and also the one that best suits the customer's tastes, way of life, and dreams. And, because many Indians do not yet have the bare necessities for life, making a purchase is often a rather solemn occasion. Some things, like dishes or cooking utensils, are ceremonially engraved by the shopkeeper with the new owner's name, which will allow their recovery throughout the vicissitudes of its existence—in case of dispute in a communal kitchen, for example.

Indians buy household products for keeps, and it is considered normal not to have exactly the same items as the neighbors own. Possessions in India are a little bit like people: They have their own character. Owners often make improvements themselves, if they have the inclination and the means. Whether this be a defiant sticker on a scooter's headlight or reflectors adorning the spokes of a bicycle, numerous accessories allow consumers to express their personality, and, in a country famous for the size of its crowds, to reveal their own identity, and not simply through actual signs of wealth.

The apparent (or real) fragility of Indian products forces us to make a sort of mute pact with them: "You'll work, and you won't break down; and in exchange I promise to keep you in as good repair as I can." When things break, they are not thrown away; they are repaired, patched up, and recycled insofar as is possible. The defenseless look of some products does not necessarily stem from their lack of solidity, but rather from the fact that they reveal their mechanisms, their entrails, straightforwardly so as to facilitate repair.

In a sense, the screws that protrude from an electric iron, even if they mark the probable recourse to disassembly, are less disturbing than the smooth, unbroken outline of a similar object as it exists in the most up-to-date Western version. Because the very nature of the latter makes it impervious to any kind of repair, it will give up its last breath and go directly into the garbage can without any other possible course of action. Its unfortunate owner will have only to get out his or her wallet, the only instrument applicable to the situation, and buy an another one. In India, such an attitude does not yet exist. You can have your shoes, your glasses, your mixer repaired on any street corner. In the shadows of an alley, a rickshaw driver, by the dancing light of a match, will confidently and without hesitation adjust his misfiring engine—and will succeed. Indian objects, which admit their defects openly and don't pretend to last forever, are in the final analysis more reliable than those in Western nations that quit suddenly, leaving their owner in the lurch.

Still, we must admit that these objects elicit only a somewhat weary condescension from those who have access to goods exported from abroad. These vibrant products, which recount the lives of their owners, which reveal the whims of those who designed or fabricated them, are today in full retreat. Young and dynamic Indians, especially, will in the future perceive them as the relics of a compulsory national effort, evocative of a traditional way of life they feel to be oppressive. They finally have some choice in their purchases, and they are naturally delighted to be able to bestride the same motorcycle as their American, Russian, or Chinese peers. In India, change is synonymous with progress, and powerful forces draw the country toward modernity—and so much the better. But, all the same, these objects, in all their individuality and idiosyncrasy, soon will no longer exist.

—Catherine Lévy

What makes Indian things so fascinating, so touching, so right and intimate all at once? We have often asked ourselves this question. Because we do not belong to their world, we look at these objects, at this generation of industrial products from the last third of the twentieth century, as outsiders. Our impulse, as well-informed tourists, to purchase and collect them slowly turned into a mindful yet joyous quest.

From the midst of this necessarily idiosyncratic collection, there arises a final coherence we did not suspect when we began. This group of nearly 250 objects has revealed itself to be representative of a historic period, of the economic and industrial evolution of India, but also of a certain taste—a fragile notion, complicated and ambiguous, that many others have tried to help us clarify. This effort, however, has turned out to be practically impossible, apart from the methodical and systematic inventory of the qualities of this or that object. There was clearly something left over that was up to us to analyze with care. And this analysis has nothing to do with the definition of taste, even of a certain taste, but everything to do with the very personal attraction for the mute fashion in which things speak to us.

SENSITIVITY

There are many ways to examine and approach objects, to allow yourself to be convinced by and attracted to them, to want to know more, and still more again, of their history, their uses, their functionality, how they were designed and produced. With Indian objects, there's nothing of the sort. More than others, they abolish the required intellectual and psychological satisfaction of discovering their history, or what they have to tell us. It is here immediately, directly, mysteriously: The jointed desk lamp, like an architect's lamp; the bucket in brightly colored plastic; or the mixer from Mumbai, New Delhi, or Jodhpur are not so very different from their European, Asian, or African brethren—not less industrial, not less solid (some Indian plastics are of a higher quality than the most modern European ones—they are also more polluting), and no less functional.

With more decoration, far from trying to conceal misery, Indian objects illuminate time past in order to end it, to finish it, to decorate it. The gravity conveyed by the product's design and the utilitarian application of decoration is irrefutable. Nesting stainless-steel cook pans, for example, have a removable handle that serves the whole set and allows for optimal storage. The owner's name engraved on the purchase gives it an added and practical worth in shared spaces beyond the dancing delicacy of the Indian calligraphy and the supple skill of the store's engraver.

INSTABILITY

We have also become used to the idea that different kinds of objects coexist. Today, some things are by definition perishable, designed to become obsolete rapidly, lasting only for a moment, and then there are those designed to be handed down to future generations. These latter objects pass on membership to the group, whether it be geographic (national or regional) or familial, and they are receptacles of memory, worth, social description. They also situate us within the realm of aesthetic sensibility. They participate in the construction of our own identity, in the same way they are involved in the creation of our lives in all their different aspects (private, personal, professional, social).

We belong to a civilization of construction. For this reason, architecture performs, in part, a symbolic function: A rational and reassuring outlook, the immutability of these constructions, is

a manifestation of our need for stability. Andrea Branzi, architect, designer, and thinker, observes, "Western countries express their destiny on Earth through the solidity of their architecture!"[1] India, which he knows well, is for him a civilization based on weaving, in the sense of a process in theory infinitely repeatable, in which the structure does not reflect a need for stability and safety but instead defines a fluctuating, decorated surface, which acts as a kind of mental representation.

Is it with this equally spiritual structure that Indians create their relationship with the world? Is this why India so naturally adopted the logic of software, manipulating networks and virtual reality with ease, producing thousands of specialized scientists and technicians?[2] In this perspective, the rapidity with which the materials and forms of objects evolve becomes clear. From one year to the next, the paper used for plates, the plastics used for bags, are refined or evolve, and the outdated style disappears forever. But what is a change for us is in India only a usual and ineluctable continuum. There is no difference between the kinds of objects, no difference between objects, no planned obsolescence. Indians draw sustenance from constancy in movement, unlike us in the West, who draw sustenance from a memory of reassuring stone. "Caring nothing for the culture of the machine, for the planning and efficiency of the twentieth century,"[3] industrial India is indifferent to the endurance of material goods and is much more passionately interested in pattern, which enables relationship with the world, connection with others, and, yet . . .

FRAGILITY

The incredible fragility that radiates from shop windows in India or from our collection seems to go together with the industrial production of the most densely populated country in the world. For Westerners, this quality makes them unusual objects, filled with happiness and the symbolic value of transgression. The captions to the photographs in this book regularly mention the relative efficiency of these objects; nonetheless, the products do not at all seem to have been designed for a limited period. There are no preconceived ideas about the life of an object. Such ideas wouldn't be Indian. Godrej refrigerators or Penjaj scooters easily give twenty or thirty years of loyal service. But Indian objects often do in fact look fragile, and they often are. This lack of self-consciousness is both strange and delightful.

In India, you often see groups of three men[4] leaning on a truck, merchandise unloaded and stored by the side of the road, hood open and engine removed, unconcernedly disassembling and reassembling the whole thing with more or less puzzled looks on their faces. But if Indian civilization accepts quite naturally the instability of repetition without a clear vision of the process, this is not through a lack of interest in machinery; on the contrary. Sociologist Djallal Gérard Heuzé,[5] who is particularly interested in the working world and in India's industrial organization, confirms that the two occupations there that create the most pride are mechanic and electrician.

In India, practical and daily manipulation of technology underpins not only the repetition of actions that produce more or less expected results but also the objective mastery of systems to be constructed and deconstructed (electric circuits, internal combustion engines, plastic presses, sewing machines). As architect Andrea Branzi notes, the ability "to internalize the mixer"[6] is not granted to all. It does seem, however, that Indians have achieved this ability. Fragility, fallibility: Are these not also the marvelous opportunity to take care of an object, to lean over it and offer it the chance to develop and reconstruct itself? To ceaselessly embody it by mastering its construction, its interiority?

IRRATIONALITY?

Indian objects are witty and spirited in every sense of the words. They are filled with sparkling details and possess a unique sensibility that refashions them again and again, in thousands of copies. What inspires workers and craftspeople to take the time to engrave little flowers on the most ordinary of glasses, to adorn radio-cassette players with flashing lights and LEDs? Rather than succumbing to the inevitable and reflexive appeal to a cultural habit that embellishes and elaborates everything (from frescoes to temple walls, from a taste for kitsch to precious textiles), I like to believe it to be the expression of an unconscious refusal to be subsumed by the market, like the stubborn recalcitrance turned against the British occupation in its day.

On a very different subject, Andrea Branzi speaks of the way in which culture and reality are "welded together," a lovely and precise expression and one particularly apt to India. He adds that "the constituent parts of irrationality contain the most significant elements of reality . . . like an expansion of tools also likely to include the irrational, of which reality is materially composed."[7] May we not see the impulse toward a new India, self-sufficient and autonomous, in this light? Unconsciously moved to include as a manifest part of its reality those irrational elements that inform its nature, India could in this way express its cavalier attitude toward industrialization, toward the ineluctable normative.

When Nehru committed his country to the path of economic and industrial autonomy by the institution of rigid protectionist laws in the 1950s, he of course precluded the establishment of foreign businesses on Indian soil; but, at the same time, he committed India to come to terms with itself, to invent, to construct its own industrial and economic reality, to remain India. In this, he succeeded perfectly. A Sumeet mixer, of entirely Indian manufacture, has its own unique sonority. The sound of the motor does not simply rise in pitch as the speed is increased: Instead, it reveals, audibly and perceptibly, the depths of its exertions by first faltering, hesitating, then gathering momentum, with every change of speed.

This mixer, which has faithfully discharged its duties on a Paris kitchen counter for many years, daily articulates to its owner's ears the imperfections of the world, the beauty of things, and the sentiments that inhabit both the world and material objects.

—Catherine Geel

1. Andrea Branzi, "Elettronica Induista." In *Intreni* 530, April 2003, pp. 334–337.
2. India is, after the United States and Japan, the world's largest producer of software.
3. Andrea Branzi, "Elettronica Induista." In *Intreni* 530, April 2003, pp. 334–337.
4. In India, commercial transportation usually requires three people in a truck: the driver, his assistant, and another person to guard the goods.
5. Djallal Gérard Heuzé, interviewed June 26, 2003.
6. Andrea Branzi, "Nouvelles de la métropole froide," design et seconde modernité ("News from the cold metropolis," design and second modernity), Les Essais, Centre Georges Pompidou, 1991.
7. Ibid.